Postcard History Series

Pensacola

in Vintage Postcards

Pensacola Beach

The Casino resort, pictured here, was Pensacola's first endeavor to provide facilities to tourists and visitors to the beach. The area's pure white sandy beaches were a natural draw to visitors. The Casino was the first of many tourist facilities to be built on Santa Rosa Island. Pensacola Beach has experienced a building boom since the 1970s, as has much of the Gulf Coast.

Postcard History Series

Pensacola
in Vintage Postcards

Pensacola Historical Society

ARCADIA PUBLISHING

Copyright © 2004 by Pensacola Historical Society
ISBN 978-0-7385-1676-7

Published by Arcadia Publishing
Charleston, South Carolina

Printed in the United States of America

Library of Congress Catalog Card Number: 2004105887

For all general information contact Arcadia Publishing at:
Telephone 843-853-2070
Fax 843-853-0044
E-mail sales@arcadiapublishing.com
For customer service and orders:
Toll-Free 1-888-313-2665

Visit us on the Internet at www.arcadiapublishing.com

Pensacola, Florida, "The Annapolis of the Air"

Pensacola has been home to the military for over 300 years. Spanish, French, British, and American troops have all been stationed here during the various occupations. With the construction of the Navy Yard, Pensacola began her long association with the United Sates Navy as a "Navy Town," a partnership that continues to this day.

CONTENTS

Introduction		7
1.	Palafox Street	9
2.	Expanding City	35
3.	Tourism Arrives	53
4.	Maritime Town	77
5.	The Military Presence	105

The Pensacola Historical Society has an excellent collection of vintage postcards. The collection is, however, the result of random contributions. By contrast, an individual collecting postcards for an area would make a concerted effort to collect examples of all known postcards on all subjects.

Using the postcards to tell the story of Pensacola's past soon revealed large gaps because postcards were not produced on historical subjects of significance. Rather, they were indicative of the interests at the time they were produced. The compilation of this book revealed that there were no postcards for the older buildings in the Seville Square Historic District. More modern postcards do include these buildings and other subjects of interest after the 1950s. Future generations will surely look at these later cards with pleasure and have questions, as we do, when we study our vintage cards.

Those who collect postcards of the Pensacola area may notice that they have postcards that are missing from the society's collection. We welcome contributions to help fill out the collection. Our thanks to the many patrons who have contributed postcards in the past.

Sandra Johnson
Executive Director

Virginia Parks
Publications Editor

Introduction

In 1559 the Spanish explorer Tristan de Luna sailed into Pensacola Bay and established a colony. A hurricane destroyed much of his fleet and provisions, and the settlement collapsed after two years, ending Spain's first attempt to colonize Northwest Florida. In 1698 the Spanish returned and built the Presidio Santa Maria de Galve. Consisting of a church, a village, and Fort San Carlos de Austria, the wooden Presidio was manned by soldiers and convicts from Vera Cruz, Mexico. The harsh living conditions made Pensacola an unpopular place to be sent. The French captured the village and burned the fort during their occupation of the city (1719–1722). Pensacola was restored to Spain by treaty after the War of Quadruple Alliance. In 1722 the Spanish built a small fort on Santa Rosa Island—the fort was destroyed by a hurricane in 1752. The Spanish rebuilt the town near present-day downtown Pensacola. In 1763 England took possession of Florida after the French and Indian War, and Pensacola became the capital of British West Florida. In 1781 the Spanish retook the city during the Siege of Pensacola, an important battle during the American Revolution. The loss of the city prevented the British troops on the Gulf Coast from going to Cornwallis's aid at Yorktown. After the Louisiana Purchase in 1803, the capital of Spanish West Florida moved from New Orleans to Pensacola. The town remained in Spanish hands until the Adams-Onis Treaty transferred the Floridas to the United States. Andrew Jackson accepted the territory on July 17, 1821, near Pensacola's Ferdinand VII Plaza.

In 1825 Congress appropriated money for the building of a lighthouse and Navy Yard in Pensacola. Initiation of the coastal defense system by the United States led to a decade of intensive fortification building. Forts Pickens, Barrancas, McRee, and the Redoubt were built during this period. In 1845 Florida became the 27th state. In 1861 Florida seceded from the Union and joined the Confederate States of America. Sen. Stephen Mallory, a resident of Pensacola, resigned from the U.S. Senate after Confederate president Jefferson Davis appointed him secretary of the Confederate Navy. In 1862 Confederate troops evacuated Pensacola and surrendered to the Union Army in May. The city government went into exile to Greenville, Alabama, and by July 1863, only 82 people remained in the city.

In 1870 a lumber boom began in Northwest Florida. Surrounded by seemingly limitless Southern yellow longleaf pine, Pensacola experienced the beginning of its economic "golden age." Lumber mills sprang up almost overnight; workers from all over the United States and Europe flooded into the city hoping to make their fortunes. The lumber barons built expensive homes north of the city, and on any given day there could be as many as 100 ships anchored in the bay awaiting loads of timber and naval stores for export. Yellow fever was a frequent visitor to the city. Mosquitoes bit infected seamen and then spread the disease throughout the city. During this time the railroads opened up Pensacola to the interior. Once an isolated backwater, Pensacola was now accessible by land as well as by sea.

Also at this time, New England fishermen came down to Florida to fish during the winter months. After the discovery of the bountiful fishing banks near Campeche, fishing fleets made

Pensacola home, and the Pensacola red snapper industry became known worldwide. Railroad cars full of fish left the port regularly. At one time 16 piers handled the loading of fish, as well as lumber, phosphates, coal, and other goods. Ships carried ballast inbound and lumber outbound. The ballast was used to reclaim land around the bay and to build Sabine Island, on which the Quarantine Station stood.

On October 25, 1886, Pensacola welcomed its first tourist attraction, the Apache Geronimo. Brought to Fort Pickens by the United States Army, the Apaches danced for the tourists who had sailed across the bay to watch the spectacle. Geronimo spent two years imprisoned in the fort before his removal to Mount Vernon, Alabama, and onward to his final destination at Fort Sill, Oklahoma. One of his wives is buried at Barrancas National Cemetery, Pensacola.

At the beginning of the 20th century, the North Atlantic Fleet began to meet regularly in Pensacola Bay before sailing to the Caribbean for maneuvers. The U.S. Navy also established a flying school here at the newly reopened Navy Yard. Renamed the United States Aeronautical Station, it had 3 instructors, 12 mechanics, 8 seaplanes, and a dirigible hangar.

In 1906, 1916, and 1926 hurricanes devastated the city and seriously damaged the fishing industry. Over logging and lack of replanting led to the end of the lumber industry. Pensacola's golden age was over.

During the 1930s new bridges out of the city helped ease travel around the country and helped start Pensacola's tourist industry. On June 13, 1931, bridges across Pensacola Bay and between Gulf Breeze and Santa Rosa Island opened to traffic. They enabled locals and visitors alike to visit Pensacola's pure white sandy beaches without the arduous boat ride across the bay. The same day these bridges opened, Pensacola's first beach destination, the Casino, opened its doors. It boasted tennis courts, bars, and its own private beach. It was not until after World War II that Santa Rosa Island was developed as a tourist destination.

12877—Red Snappers caught near PENSACOLA, Fla.

Pensacola was known as the "Red Snapper Capital of the World." Initially local fishermen sold their catch at the market in New Orleans and at other coastal towns. The fish were wrapped in banana leaves, and each "bunch" cost around $2. Floridian Dr. John Gorrie revolutionized the transportation of perishable goods when he invented mechanical refrigeration. The production of ice enabled the exportation of fish both nationwide and worldwide. The largest fishing fleets were those of E.E. Saunders and the Warren Fish Company.

One

Palafox Street

Palafox Street is shown here looking south, c. 1907. For more than 100 years, Palafox Street was the city's business, retail, and social center. The town's important public buildings were constructed on or near this busy street. To the right is the Brent Block named for F.C. Brent, whose private bank merged with the First National Bank. The Brent and Blount Buildings, completed in 1906, replaced structures destroyed during the great Halloween night fire of 1905.

A Mardi Gras parade proceeds up Palafox Street in this view c. 1909. The celebration of Mardi Gras (French for "Fat Tuesday") in Pensacola began in 1874 but did not attract much interest. In 1900 Mardi Gras was renewed and celebrations began that included elaborate costumes and brightly colored floats. More than 100 years later Mardi Gras is still a major celebration in Pensacola.

A retouched 1940s view depicts Palafox Street in the evening. The San Carlos Hotel is shown after the 1927 expansion added over 300 new guest rooms. The hotel was located at the corner of Garden and Palafox. Palafox, north of Garden, is a divided street with a center grassy area where a bust of Martin Luther King Jr. was later placed. The area was named the Martin Luther King Jr. Plaza.

A view looking to the north on Palafox Street shows how vibrant downtown Pensacola was in the 1940s. As with many downtown areas in the United States, businesses such as the Sears and Roebuck Department Store later relocated to suburban malls.

North Palafox Street is shown in this busy view from the early 1940s. Some of the Victorian-era buildings have been modernized to reflect the popular Art Deco style of architecture. This view shows the Rex Theater, Rhodes Furniture Store building, and the new Federal Court House completed in 1938–1939.

The top postcard is a c. 1900 view of Plaza Ferdinand VII, named for the King of Spain. The plaza was originally a Spanish military parade ground. The large white building in the background was built in 1887 as the United States Post Office and is now the Escambia County Court House. In the center of the plaza stands the Chipley Monument. William Dudley Chipley, a great promoter of Pensacola, expanded North West Florida's railroad system and helped develop Pensacola's economy. The three-story building to the extreme right was later demolished to make way for the ten-story American National Bank Building in 1909, shown in the lower view. The "skyscraper" American National Bank Building now houses offices and is known as Seville Tower.

Pensacola's United States Post Office, on the corner of Palafox and Government Streets, was completed in 1887. This impressive structure was one of the largest and finest public buildings constructed in Pensacola up to that time; it later became the Escambia County Court House.

Constructed in 1908 as the First National Bank, this building was designed to resemble an ancient Greek temple. Now owned by the Escambia County Government and used by the clerk of the court, it is impeccably maintained and retains many of its original features, such as the stained glass window that pays tribute to Pensacola's maritime past and the old bank safe.

Built by Daniel F. Sullivan, a local lumber and banking tycoon, the Pensacola Opera House opened on January 4, 1883. The ornate, Second Empire–style building hosted some of the theater's greatest performers, including Sarah Bernhardt and John Philip Sousa. In 1917 the building was demolished because of damage from the 1916 hurricane. Bricks from the outside walls and the painted iron balcony railing were installed in the new Saenger Theatre built in 1925.

City Hall, Pensacola, Florida

Built at a cost of $100,000 and over looking Plaza Ferdinand, this Spanish renaissance structure served as Pensacola's city hall from 1906 to 1986. In 1988 the solid old building was transformed into the new home of the T.T. Wentworth Jr. Museum.

County Jail, Pensacola, Fla.

Completed in 1912 as the Escambia County Jail and Courthouse, this building now houses the Cultural Arts Center. Empty since the 1950s, the building was severely deteriorated until restored as the new home of the Pensacola Little Theater. The old building was gutted and transformed into a state-of-the-art theater, with classrooms and rehearsal halls.

"Mackey Takes in Washing for a Living" was the slogan for the Empire Laundry Company (visible in the background) located at 22 North Palafox Street. Having a first-rate laundry in town was much appreciated in the days when doing laundry was a laborious and back breaking task.

The Child Restaurant closed during the 1980s, but its 1920s tiled, Art Deco–styled façade remains virtually unchanged today. The back of this postcard reads "Good Food- Popular Prices Where the Home Folks Eat."

Depicted here is the interior of the Stagno Brothers store c. 1915. Located at 615 North Palafox Street, Stagno Brothers was a general merchandise and grocery store. Owned and operated by Greek immigrants, Stagno's was typical of the many shops and businesses owned by immigrants who made Pensacola their home.

In business for more than 50 years, Rox Photo Studio was located at 578 South Palafox Street. A full service photo shop, Rox sold a variety of photographic supplies and provided such services as film development. Many Pensacola natives can remember going to Rox to sit for a high school graduation photo, a family portrait, or for formal wedding portraits.

Florida State Militia troops occupy the center area between Palafox Street in this 1908 view during the streetcar worker's strike. Fearing possible violence, city officials requested that the state government send troops to keep order. The trolley tracks ran down the center of the street, and there were open drainage ditches running down the sides of the street.

A pair of trolley cars crisscross Palafox Street in this view looking to the south. The Street Railway Company was established in 1884 for the area's first public transportation system. Horses were used to pull the trolley cars until the four miles of tracks were electrified.

This rare view shows a group of passengers onboard a trolley car *c.* 1910s. Notice that the seats are in fact wicker chairs and appear to be just sitting on the trolley floor. Seated on the right second back is Mr. A.V. Clubbs, a local businessman and philanthropist who would later have

a school named in his honor. Clubbs's daughter Occie, in the front seat to the left, became a popular high school history teacher. Replaced by automobiles and buses, the last trolley ran in 1931.

The city's new prosperity was evident when the San Carlos Hotel opened in 1910. Constructed for $500,000, the San Carlos Hotel was the pride of the city and the social center for the community well into the 20th century. As people and businesses began to abandon the downtown area after World War II, the hotel fell into decline. Closed in 1980, the beloved landmark was demolished in 1993.

Lobby and Grand Stairway, San Carlos Hotel, Pensacola, Fla.

These two cards show the elegant interior of the San Carlos Hotel. The lobby featured a grand staircase clad in three types of marble, with bronze railings and a two-story high stained glass dome. The San Carlos was the ultimate in luxury in Pensacola and travelers were surprised and impressed that a city the size of Pensacola had such a large and fine hotel.

The Thiesen Building, designed in the Renaissance Revival style, was constructed by Danish-born immigrant Christian Ustrup Thiesen in 1901 as an office building. At that time, the five-story structure was the tallest building in the city and featured steam heating and elevators, a first for the city of Pensacola.

The 10-story American National Bank Building was completed in 1909 and was for a brief period the tallest building in Florida. Often called a skyscraper, the building was constructed with steel beam framing and brick exterior walls to make it as fireproof as possible. The exterior facade is decorated with ornately carved limestone flowers, vines, and the faces of cherubs.

Palafox Street, looking South, Blount Building in Foreground, Pensacola, Fla.

The seven-story W.A. Blount Building was built in 1907 for $200,000. Designed to be completely fire proof, the building replaced an earlier block of commercial buildings destroyed in the great Halloween night fire of 1905. William Alexander Blount was a local attorney and president of the American Bar Association. There is also a street named for him.

HOME OF GOV E A PERRY 1885 BUILT ABOUT 1866

Florida governor E.A. Perry's private home was located at the corner of Wright and Palafox Streets. Edward Aylesworth Perry, captain of the Pensacola Rifles, rose to the rank of brigadier general in the Confederate Army. After the war he returned to practice law in Pensacola. In 1885 Perry became the 14th governor of Florida and the first from Pensacola. Today the building is home to the Scottish Rite.

PALAFOX STREET, NORTH FROM WRIGHT. CHRIST CHURCH AND WATER TOWER, PENSACOLA, FLA.

Built in 1903, Christ Church is on the corner of Palafox and Wright Streets. The interior features a circular domed ceiling painted dark blue with gold stars to resemble the night sky. The new Christ Church replaced an earlier building located on Seville Square and dating to 1832. Wright Street was named for Benjamin Drake Wright, an attorney who attended the first Constitutional Convention in Florida.

Immanuels German-English Lutheran Church, Pensacola, Fla.

The Immanuel German-English Lutheran Church is located at 20 West Wright Street. The congregation was established in 1885 by families of German descent who first held their services in the old First Presbyterian Church on Intendencia Street. Later that year they built their own church on the corner of Garden and Baylen Streets. In 1912 they moved again to this church on Wright Street.

26

This view is the exterior of St. Michael's Catholic Church. Dedicated on June 6, 1886, the church has changed very little since it was built. Architect Charles Overman designed the building and contractor John F. Kehoe, both of Pensacola, constructed the church. Former pastor Father Blaasen donated the church bell.

This rare view shows the interior of St. Michael's Catholic Church, c. 1890. The carved wooden altars were gifts from Mr. and Mrs. F.C. Brent. The stained glass was bought with donations and is by Emil Frei of Munich, Germany. The names of early Catholic families are memorialized on the Stations of the Cross.

The First Presbyterian Church was established in 1848. In 1889 the congregation moved from their first location to a new church on Chase Street, shown here. In 1968 they moved to their present location on Gregory Street.

Pensacola has always had a diverse religious population. Baptists, Lutherans, Methodists, Catholics, Jews, and Episcopalians are all represented in the community. The First Baptist Church, on the corner of LaRua and Palafox Streets, was completed in 1895. The church was remodeled in 1922 and 1956.

First Methodist Church, Pensacola, Fla.

Shown above is the First Methodist Church located just off Palafox Street on Wright Street. The original First Methodist Church was demolished in 1909 to make room for the San Carlos Hotel. Below is the Gadsden Street United Methodist Church, built 1901–1902. Gadsden Street was named for Lt. James Gadsden, who was an aide to Andrew Jackson. Both of these church buildings stand today and remain virtually unchanged.

Gadsden Street Methodist Episcopal Church,
South Corner Gadsden Street and Ninth Avenue,
Pensacola, Fla.

Constructed in 1886, Public School No. 1 was located at 614 North Palafox Street, north of the business district. The school was later demolished to make way for Pensacola High School in 1921. Palafox Street was named for the Spanish general Jose de Palafox y Melzi.

The Florida State Board of Health Building is located at the busy intersection of Palafox and Cervantes Streets, directly across the street from Beth-El Temple. Reflecting a style of architecture popular in the American South, the building has many ancient Greek-inspired features.

Court House and Armory, Pensacola, Fla.

The Escambia Court House was built in 1883 for $32,000, and the structure to the left was built as an annex to the original building in 1895 for an additional $33,000. Both buildings were demolished in 1938–1939 and replaced by the new Federal Court House Building. The clock in the tower was removed and stored by the Pensacola Historical Society. Today it is displayed in a glass structure in front of the new Escambia County Court House.

The old YMCA building was located at 402–406 North Palafox Street. Built in 1903, the YMCA officially opened in 1906. The club offered young men athletic facilities, including a gymnasium, bowling alley, café, and billiard room. Night classes were also held there, and Boy Scout troops received sponsorship from the club. Membership cost $20 a year for men, and $5 for boys aged 14–18. The building was demolished in 1969.

Florida Theatre

The Florida Theatre, at 186 North Palafox, was one of four movie theaters located in a row along the east side of Palafox Street. The other theaters were the Isis, the Rex, and the Saenger Theatres. The Florida Theatre was closed in the mid-1970s when it was replaced by theaters constructed next to the sprawling suburban shopping malls far from the city's downtown center.

This 1942 view is of the Barrel of Fun nightclub, at 329 South Palafox Street, which was just one of the many establishments that catered to locals and to the hundreds of United States Navy sailors stationed at the nearby base. Palafox Street had an amazing variety of stores, restaurants, and nightclubs to keep Pensacolians entertained.

This night time view shows some of the businesses on South Palafox c. 1928. On the left is the Saenger Theatre, which opened on April 2, 1925. The opening night feature film was Cecil B. DeMille's *The Ten Commandments*.

OLD SPANISH CEMETERY. A GRANT TO ST. MICHAEL'S PARISH BY THE SPANIARDS ABOUT 300 YEARS AGO. PENSACOLA, FLA.

Already used as a burial ground for many years, King Phillip of Spain officially established St. Michael's Catholic Cemetery in 1807. (Pensacola was controlled by the Spanish at this time.) People of more than a dozen different nationalities can be found within the cemetery. Early prominent citizens of Pensacola buried in St. Michael's include Stephen R. Mallory, secretary of the Confederate Navy; Joseph Noriega, elected first mayor of Spanish Pensacola in 1821; Salvador T. Pons, first African American to be elected mayor (he served in 1874 and 1878); Dr. Eugenio Sierra, surgeon for the Spanish Army who arrived in Pensacola in 1785; and John Innerarity, a partner in the Panton-Leslie Company who traded with the Creek Nation.

Two

EXPANDING CITY

Built in 1911, the Bayou Texar Bridge was one of the first constructed in Pensacola. The wooden structure cost $3,700, and was 1,050 feet long and 20 feet wide. East Pensacola Heights, on the north east side of the bridge, began to develop as a residential neighborhood. The name "Texar" is from the Spanish meaning "a place where bricks are made." There were many brickyards along the bay at one time.

In the foreground are the railroad trestle and tracks that ran along Scenic Highway. In the distance is the Pensacola Bay Bridge that opened to traffic on June 13, 1931. The three-mile-long toll bridge cost $2.5 million and had an electrically operated, double-leaf bascule opening for shipping. The monthly toll fee was $5. Replaced in 1960, the old bridge serves as a fishing pier.

This view shows North Barcelona Street, looking north, c. 1910. As the town grew, families moved into new residential neighborhoods. This tree-lined street was in North Hill, one of the more affluent areas of Pensacola.

These houses, built during the 1920s, are a few of the beautiful homes in historic North Hill. Lumber barons built many elaborate houses during Pensacola's economic boom. North Hill is a 50-block residential section north of Gage Hill and boasts many architectural styles. Most of the homes date from the 1890s to the 1920s and have been lovingly restored by their present owners.

Scenic Highway along Pensacola Bay, Pensacola, Fla.

Scenic Highway runs north of the city along Escambia Bay. This winding road gives drivers a sweeping view of the bay and Santa Rosa County beyond. During the 19th century, brickyards operated along the bay at Gaberone and Bohemia. Brick makers extracted clay from outcrops in the bluffs. Bricks from these brickyards were used to build many local forts and Fort Jefferson on the Dry Tortugas.

MOST ANY AFTERNOON AT SIMMON'S PLACE

MAGNOLIA BLUFF SCENIC HIGHWAY PENSACOLA, FLA.

Simmon's Place on Magnolia Bluffs on Scenic Highway was a popular spot to stop during an afternoon drive along the coast. From the terrace, patrons could enjoy the view across Escambia Bay. As more people took to the roads during the 1930s–1950s, restaurants and bars opened to meet the needs of these travelers.

Rapid Transit in PENSACOLA, FLA.

This postcard pokes good-natured fun at the leisurely pace of Southern life. This form of transportation was used around the city by draymen who made their living delivering goods to the homes of city dwellers. With the arrival of the automobile the oxcart was no longer seen around town.

During the late 1940s Rand's Bus Station was at 16 East Romana Street, a short distance from Palafox Street. Dominic L. Rand operated the bus station, a 24-hour taxi service, a car hire, and a full service garage that also offered automobile storage.

The Pensacola Sanitarium was located at 380 West Garden Street. As the city grew, so did the need for health care. In 1909 a group of nine local physicians opened the sanitarium. Although woefully inadequate for the population of over 20,000, the 20-bed facility had an X-ray room, pathology lab, operating and scrub rooms, and an elevator. It closed in 1915 after the ultra-modern Sacred Heart Hospital opened.

Pensacola Hospital—also known as Sacred Heart Hospital—on Twelfth Avenue was Pensacola's first modern hospital. The Sisters of Charity of Saint Vincent De Paul ran the facility. The 125-bed hospital cost $486,000. Previous medical facilities included the 20-bed Pensacola Sanitarium, Dr. Herron's Marine Hospital, and the Maternity Hospital. The old hospital building now houses small businesses and restaurants.

The new Sacred Heart Hospital opened in 1965 on a 28-acre tract off Ninth Avenue. The 6-story hospital had 250 beds, in private and semi-private rooms, a maternity suite, and 5 surgical suites. The Intensive Care Unit was the first of its type in Northwest Florida and had 24-hour care. The hospital was equipped with all the latest equipment.

On October 17, 1951, Baptist Hospital, West Moreno Street, opened. The 4-story, 140-bed hospital employed 100 medical professionals to oversee the 4 operating rooms, post-op and recovery rooms, and modern obstetrical suites. The patients could choose from 2- or 4-bed rooms, and each room had a telephone. Today Baptist Hospital has 749 beds, over 5,000 employees, and a medical park on University Parkway.

A. C. Clubb School, Pensacola, Fla.

The old A.V. Clubbs School is located at 1310 Twelfth Avenue in East Hill. Opened in 1911, the junior high school closed in 1986. Named for prominent local businessman and member of the school board, Alexander V. Clubbs, it was initially built to serve 200 pupils at a cost of $557,812. Additions in 1937 and 1955 enlarged the school to include another building of classrooms, a cafeteria, and band room. It is now N.B. Cook Elementary School.

Pensacola High School sat on Palafox Street across from Lee Square. The school opened in 1922 and closed in 1953 when the high school moved to a new facility at Maxwell Street and A Street. Pensacola Junior College took over the building, which was destroyed by fire in the late 1950s.

The Convent of Perpetual Adoration, Sacred Heart Academy, 912 East La Rua Street at Tenth Avenue, operated between 1911 and 1952. Boarders stayed on the third floor, and a chapel separated the convent on the east side from the school on the west side. The school was run by the Sisters of Perpetual Adoration (later Sisters of the Most Holy Sacrament).

Fire Department of Pensacola, Fla.
Chief Bicker and 1st Ass't Chief Riera in buggy t

The first Volunteer Fire Company #1 formed in 1821. Horses pulled the engines and water pumps until 1915, when the department began trading in horses to buy motorized fire trucks. Chief Bicker's horse, named Peter Mike, was very well trained. When he retired, Peter Mike had a difficult time letting go. One day in 1910, while Hilda Bicker, the chief's daughter, was out in a buggy drawn by Peter Mike, a fire wagon went by on the way to a fire. Peter Mike instinctively

took off after the wagon, and nothing the 14-year-old could do would persuade him otherwise. In the late 1940s a stray dog, called Poochie, adopted firefighter "Mutt" Bonifay and would follow him to work. Eventually, Poochie adopted the whole department and rode with the firefighters to all the fires. The fire department is pictured here on September 2, 1909.

Navy Point Shopping Center in Warrington was the first shopping mall in Pensacola. It opened in the mid-1940s and contained a theater, service station, offices, and stores. Built at a time when Americans were taking to the road in huge numbers, the parking lot could hold 400 cars.

During the 1940s the Silver Dome Skating Academy was at 37 East Chase Street. The rink had a rock maple floor and a two-and-a-half-story Romanesque-style lobby with a dome ceiling.

Pensacola Dairy Bar, 141 East Gregory, opened in 1926. Its unusual facade made it a well-known landmark. Teenagers frequented the Dairy Bar, perhaps lured in by the "Teenburger." The building was demolished in the 1970s during the construction of I-110.

"Southern Fried Chicken"

Bartel's Restaurant, 120 South I Street, opened its doors in 1923. The specialty of the house was "southern fried chicken" and homemade wine made from local scuppernong grapes and blackberries. The restaurant was in business for over 70 years.

In 1953 George and Perry Baniakas opened the Driftwood Restaurant at 27 West Garden Street. They served food that reflected George's Greek heritage. The white lights decorating the dining room at Christmas became so popular that the owners left them up permanently, and they became a well-known feature of the Driftwood.

Martines Restaurant was located at the corner of Mobile Highway and Warrington Road. Built in 1942 by Greek immigrant James Marks and his wife Christine, the restaurant derived its name from Marks (Mar) and Christine (tine). This popular eatery had a dining room and a drive-in where carhops dressed like Spanish peasants would wait on customers. The restaurant closed in the 1970s.

Carpenter's restaurant, c. 1970, was located on the corner of Barrancas Avenue and Old Corry Field Road. The restaurant's heyday was in the 1950s, and you might have seen Lucille Ball and Desi Arnaz there when they were in town visiting Desi's relatives.

BAY VIEW PARK, PENSACOLA, FLA.

As the city grew and people had more free time, outdoor recreational activities became popular. With Pensacola's climate and easy access to water, boating and swimming were favorite pastimes. Bayview Park in East Hill on Bayou Texar was a popular destination for those wanting to hire a boat for an hour or two. Families frequented the park, picnicking and swimming in Bayou Texar's safe waters. During the 1940s and 1950s visitors could also enjoy a movie shown on a giant outdoor screen.

BAY VIEW PARK BATHING BEACH, PENSACOLA, FLORIDA

Boating was a very popular pastime at the turn of the century. Women found it especially liberating, as this picture shows. Although modesty precluded them from wearing skimpy costumes, they could remove some layers and go barefoot while on the water. Small craft could be hired quite cheaply, and boaters could get away from the city heat for a while.

The second clubhouse for the Pensacola Country Club, located on Bayshore Drive, was destroyed by the 1926 hurricane. Established in 1902 the first clubhouse had been destroyed during the 1906 hurricane. The current clubhouse is in a colonial house, built on the property in 1907. By 1924 the club boasted an 18-hole golf course, tennis courts, croquet lawn, picnic areas, and a dining room and dance floor in the clubhouse.

Entrance to St. John's Cemetery, Pensacola, Fla.

Escambia Lodge No. 15. F.&A.M bought the site for St. John's Cemetery on G Street for $3,000. The lodge operated the cemetery until 1905, when they formed a separate company to manage the site. In 1908 they added a chapel, office, and waiting room. There are 10,000 marked graves and perhaps as many as 5,000 unmarked graves.

Three

TOURISM ARRIVES

This view of Pensacola Beach, c. 1900, shows that people were willing to make the boat trip to enjoy the beautiful white sandy beaches. The sea breezes probably offset some discomfort endured by these early beach goers dressed in heavy suits and long dresses.

Steamer Baldwin just landing at Santa Rosa Island, Gulf of Mexico, Pensacola, Fla.

The steamer *Baldwin*, c. 1910, was a wooden passenger excursion boat that took daytrippers to and from Pensacola Beach on Santa Rosa Island. Until 1931 the only way to reach the island was by boat.

First Official Auto Trip Across Pensacola Bay Bridge, Pensacola, Fla.

Until the 1930s most beach visitors were from Pensacola. Tourism did not begin until 1931 when the city began to encourage out-of-town visitors. On June, 13 1931, Pensacola Bay Bridge opened to much fanfare. The toll bridge enabled people to drive across Pensacola Bay for the first time. In 1948 the bridge was renamed the Thomas A. Johnson Bridge in honor of the man who had the toll removed.

Wayside Park, 1955, is a rest area and picnic spot at the Pensacola end of the Pensacola Bay Bridge. From here people wishing to fish from the old Bay Bridge can gain access to the Pensacola end of the bridge. The Pensacola Visitor's Center is also located here.

The Pensacola Beach Bridge across Santa Rosa Sound also opened on June 13, 1931. This bridge completed the journey to Pensacola Beach. The wooden swing bridge, built for $250,000, was replaced in 1949 by a concrete toll bridge. The cost of crossing the bridge was 25¢. In the 1970s the second bridge was replaced by a bridge named for Congressman Bob Sikes. The old bridge is now a fishing pier.

Aerial View of Santa Rosa Island and Pensacola Beach, Pensacola, Florida

This view shows the Casino a few years after it opened, c. 1935. This resort was the first tourist facility built in Pensacola. It opened the same day as the two bridges, and Pensacola officially became a tourist destination. The Casino, built at a cost of $150,000, had all the latest amenities: tennis courts, a bath house, a dining and dance hall, and a 1,200-foot fishing pier.

The World's Finest and Whitest Sand Beach on Gulf of Mexico, Pensacola Beach, Fla. and Casino

The Casino resort and Fishing Pier are depicted in this postcard. Once the Casino opened, Pensacola formed the Chamber of Commerce to take advantage of its new economic endeavor. It organized beauty contests on the beach, and the YMCA sponsored boxing matches every Tuesday evening. Visitors could sit on the newly constructed boardwalk and enjoy a meal, and after the end of Prohibition, a drink.

The Casino Fishing Pier boasted that it served the coldest beer in Pensacola. In this view visitors are enjoying a concert on the open air stage. The pier was destroyed during a storm in the 1950s

and rebuilt. Back-to-back hurricanes Erin and Opal in 1995 destroyed this fishing pier, too. The current pier remains unscathed.

THE GULF COAST AT PENSACOLA, FLA.
PENSACOLA IS THE FRISCO'S PORT TO
AND FROM THE SEVEN SEAS.

This postcard advertises Pensacola as "Frisco's port." The St. Louis and San Francisco Railroad's Frisco Line connected its United States routes with worldwide shipping routes at the Port of Pensacola. Pensacola was the Frisco Line's port for exports to Cuba. From the 1930s until the 1970s the Frisco Line was an important part of the local economy.

Frisco Lines Depot

The Frisco Lines depot was located on Garden and Coyle Streets. The Spanish-style building had a bell tower and flower gardens along Garden Street. The waiting room walls were decorated with painted murals. The building was demolished in 1966.

Beach at Santa Rosa Island, Pensacola, Fla.

This postcard of Pensacola Beach c. 1910 shows that the strict dress codes of the 19th century were relaxing gradually. Although men in suits and ladies in dresses predominate, several more adventurous souls have donned the new swimming outfits.

This is a close-up of bathers wearing early swimming costumes. These woolen dresses, often worn with mop caps and stockings, covered most of the body, but women were at least spared from wearing corsets.

This view shows Pensacola Beach during the 1950s. Pensacola's tourist industry has grown over the years and has become one of its major sources of income. Its sugar white sands continue to lure sun worshippers to the Gulf of Mexico, and the beach has undergone a transformation. Developers have built luxury homes and condominiums all along the coastline, and restaurants, shops, and rental businesses have established themselves in the area.

SANDERS BEACH, PENSACOLA, FLORIDA

MUNICIPAL BATHING BEACH

Sanders Beach, c. 1950s, is a public bathing area on Pensacola Bay on the eastern side of Bayou Chico. Sanders Beach was particularly popular with visitors during Prohibition, because they could still buy liquor there.

Bayou Chico, (Spanish for "small" or "little") c. 1910, is a small bayou that lies to the west of the city. As the postcard shows, the bayou was a popular place to canoe. If this were too energetic an activity, the large variety of fish in the bayou made fishing an acceptable alternative.

This postcard shows the drive to Ferry Pass fishing camp. The live oak trees in this picture have Spanish moss growing on them. This air plant is common in the Southern United States. So named because it resembled the beards of the Spanish soldiers who came here, the moss is collected, fumigated, and sold to florists for use in floral arrangements.

YACHTING ON THE BAY AT PENSACOLA, FLA.

Sailing and boating have always been popular. In 1908 local enthusiasts formed the Pensacola Yacht and Motor Boat Club. The location of the clubhouse has included an office in Cushman's Alley, the Pensacola Pilots Association building, and a World War I experimental concrete vessel, the *General Wilson*. The present location is on Bayou Chico on the J.W. Muldon estate, purchased in 1948.

Sharking Party and their fifteen foot catch, Pensacola, Fla.

The waters around Pensacola yield a variety of fish. Fishing boats off load their catch daily behind retail outlets on the dock. Shoppers can buy fish literally "straight off the boat."

16212—A 300 lb. Grouper off Pensacola, Fla.

The man in this picture proudly displays his catch, a 300-pound grouper. Sport fishermen can charter boats to take them deep-sea fishing, and fishing tournaments are an annual highlight. Fish types include tarpon, kingfish, cobia, barracuda, bluefish, bonito, bass, sheepshead, grouper, mullet, flounder, Spanish mackeral, pompano, drum, croaker, red snapper, and shark. Shellfish are also abundant, and shrimp and oysters are a local specialty.

12882—Escambia Hotel, PENSACOLA, Fla.

Escambia Hotel on Palafox, c. 1900, was originally the Continental Hotel. The 100-room Escambia Hotel opened in 1895. Constructed on swampy ground, the builder drove the pilings through cotton bales placed in the ground. Steam-heated rooms cost $2.50 a night. Facilities included a bar, a wine room, a Japanese tea room, and a billiard room. The hotel closed in 1910, unable to compete with the San Carlos Hotel.

FLORIDA HOTEL — U. S. Highway 90 — PENSACOLA, FLORIDA

The Florida Hotel, 211 West Cervantes Street, was previously a private residence. The hotel opened in 1943, and rates started at $2 for a room with bath. The hotel closed in 1978, and the building has since housed businesses and residential units.

Sportsman's Fishing and Hunting Club, Paradise Beach, Pensacola, Florida

Paradise Beach Hotel, near Lillian Bridge on Perdido Bay, c. 1944, opened in 1932. This 21-bed hotel had a French chef, a large dining room and dance floor with orchestra pit, gambling rooms, slot machines, a bath house, and rustic log cabins. In 1937 a room with bath cost $1 a day, and a cottage cost $15 a week. It closed in the late 1960s.

TROPICAL ROOM, PARADISE BEACH HOTEL, PENSACOLA, FLORIDA

These views show the new trend in traveling accommodation—motels. Above is Azalea Motel and Gardens, U.S. 98, one mile from Pensacola Beach. Below is Bay Bridge Court, 916 East Gregory Street, downtown Pensacola. As Americans took to the road, this new style of hotel, known as the motel, spread across the country. Motels were designed specifically to accommodate the motorist. Built as a series of rooms, all accessible from the parking lot, the weary traveler could park his car outside his motel room.

The Pensacola Motor Lodges and Motel, Highway 90 in Brownsville, promised the motorist, "Sleep in safety and comfort without extravagance." This was the aim of every motel, to provide a good night's rest without the expense of a hotel. The Pensacola Motor Lodge even provided lockable garages if needed. The motel is still in business.

Town House Motor Hotel, 16 West Cervantes, Highway 90, was in business from 1950 to 1972. Here the weary motorist could enjoy a swim in the pool before cocktails in the Blue Angel Room and dinner in the Coach Room. The rooms had air conditioning, phone, television, and radio. Their slogan was "exclusive but not expensive." The building is now used for offices.

73

The Court Chandler was on Highway 90 in Brownsville. Brownsville is west of downtown Pensacola and was one of the first suburbs. In 1908 developer Lucius Brown established Brownsville when he built shotgun houses on a seven-block parcel of land. Shotgun houses are so named because you could fire a bullet through the front door and it would pass through the back door without hitting anything.

Palmetto Hotel is located at 3725 Mobile Highway, (U.S. 90). Mobile Highway is one of the streets in Pensacola that can be confusing. It runs into Cervantes Street that later becomes Scenic Highway. The most confusing street to motorists has to be one that changes its name five times—Highway 296. Starting in Bellview as Saufley Field Road, it changes to Michigan Avenue, Beverley Parkway, Brent Lane, and finally Bayou Boulevard.

74

This early example of a tourist postcard shows views of the city. Interestingly, it also shows views of a sugar plantation and coconut trees, none of which can be found in Pensacola.

This postcard, dated 1908, is more representative of Pensacola. It shows local scenery and city landmarks including Plaza Ferdinand VII, bottom, and the lighthouse, center right.

76

Four

MARITIME TOWN

PENSACOLA BAY, Deepest Harbor, 33 ft. of Water on the Bar Channel, South of New Port News.

A fleet of sailing ships are shown docked at Pensacola. This postcard touts Pensacola's natural deep water harbor, a feature that attracted the first Spanish settlers. Unfortunately, once settlers arrived here, they found it difficult to journey inland. The rivers emptying into the Gulf of Mexico were too shallow to navigate by boat, and the few existing Native American and animal migratory trails were unsuitable for wagons.

This close up view shows a pier between a forest of ships masts and rigging. During the lumber boom of the late 19th century it was not unusual for 80 to 100 ships to be anchored in the harbor awaiting cargo. The city's saloons and billiards halls did a brisk business, and *The Pensacola Gazette* had many a story about drunken sailors drowning or falling down hatches.

A group of local children sit on a jetty made of the stones used by sailing ships as ballast. The stones provided weight in the lowest part of the ship to give the vessel stability. These stones were off loaded at the various ports the ship visited once cargo had been taken onboard. These rocks were later reused to build foundations for many Pensacola houses as well as sea walls. In this view ballast stones are being used to construct a new railroad bridge.

Gulf, Florida and Alabama
Railway Company Coal Pier,
Pensacola, Fla.
Electrically Operated,
Capacity 600 Tons per hour.

The Gulf, Florida and Alabama (GFA) Railway Company Coal Pier has an electrically operated and moveable loading chute that could load 600 tons of coal per hour. The chute was mounted on tracks and could be moved up and down the pier to wherever it was needed. The GFA Railroad became the Muscle Shoals, Birmingham, and Pensacola Railroad.

Over a Million Dollars worth of Mahogany and Red Cedar Logs, in Log Boom, Pensacola, Fla.

Over $1 million worth of mahogany and red cedar logs await loading onto ships. In the background is the grain elevator at Tarragona Wharf. Built in 1898 the elevator had a capacity of 500,000 bushels of wheat. The elevator was damaged beyond repair during the 1926 hurricane that decimated the port.

479 THE HARBOR, PENSACOLA, FLA.

The elaborate Palafox Street wharf is seen from the top of the grain elevator. This view shows how vibrant the Port of Pensacola was about 100 years ago. The transition from sail-powered ships to modern steam-powered vessels is yet to be completed as both types of these ships are shown docked at the piers.

60 COMMANDANCIA AND TARRAGONA STREET WHARVES, PENSACOLA, FLA.

This is a view of Commandencia Street and Tarragona Street Wharves. This complex formed the core of Pensacola's cargo handling facilities. The Commandencia Street Wharf was originally built in 1859, then rebuilt in 1869. The two-level pier could load and unload general freight. The Tarragona Street Wharf had a transit shed used for storing fertilizers, and on the other side of the pier were open tracks for loading lumber.

This c. 1920s image shows the Bull Line's cargo ship *Arlyn* docked at Palafox Pier. Originally built in 1828 the wharf was rebuilt in the early 1870s. The double-decked pier had two sets of train tracks that allowed ships to load and unload directly onto freight cars. Built entirely of wood, the massive structure later burned and was replaced with concrete and steel docks.

This postcard, c. 1905, has a stern view of the British steamship *August Belmont* of London as she sits in the old Spanish dry dock at Pensacola undergoing repairs. The dry dock was brought to Pensacola from Havana, Cuba. Ships needed maintenance or repairs that required that they be dry docked. With its own dry dock facilities Pensacola was well equipped to perform this work.

An early 1920s view of Pensacola's waterfront is depicted in this postcard. Not all of the activity in Pensacola Bay was reserved for commercial shipping as this family setting out on a boating excursion proves. Below the boat's stern is the stamp of the Rox Photo Studios, longtime Pensacola studio, which took several of the images used on these postcards.

This view from 1917 shows the lighthouse with a dirigible in the background. Situated on a bluff overlooking the entrance to Pensacola Harbor, the Pensacola lighthouse stands 140 feet high and is 30 feet in diameter at its base. Replacing an earlier lighthouse dating to 1824, the current lighthouse was first lit on January 1, 1859. The original first order Fresnel lens is in use today. The keeper buried it at the beginning of the Civil War and replaced it with an inferior lens. After the war the original lens was put back. Before electricity, keepers had to climb the stairs every two hours to pull the weighted chains of the clockwork mechanism that kept the light rotating. A single whale oil lamp originally lit the lens, and keepers had to haul five gallon cans of whale oil up to the lamp room. For 15 years Michaela Ingraham kept the light after her husband died. The lighthouse was taken over by the U.S. Coast Guard in 1953 and automated in 1965.

The Santa Rosa Island Life Saving Station assisted in the rescue of many a shipwrecked mariner. In the early morning hours of August 7, 1894, the Norwegian sailing ship *Catherine* ran aground in a severe storm outside Pensacola harbor. The crew of the nearby life-saving station were absent at the time of the accident. Captain Broadbent, the station master, and his two young daughters Isabella (16) and her sister Sarah (12) helped rescue all 19 men from the wrecked ship. The sisters, who were lauded as local heroes, were later given gold medals from Oscar II, King of Sweden and Norway.

Above is a close-up view of the deck of a fishing schooner unloading its catch. Below, ice is loaded onboard the boats to preserve the fish. Fishermen from New England brought their fishing boats to Pensacola to fish during the winter. After the red snapper banks near Campeche, Mexico, were discovered, Pensacola became the base for the red snapper fleets. Red snapper from Pensacola were exported worldwide.

Unloading Red Snappers, Pensacola, Fla.

A group of fishermen stands on a Pensacola dock admiring their generous catch of red snapper. This brightly colored fish helped to build Pensacola's economy at the turn of the century. Working at sea was a dangerous business during the storm season, and local cemeteries contain the graves of fishermen and sailors from all over Europe.

DEEP SEA FISHING SMACKS, PENSACOLA FLORIDA

Their work done for the day, part of Pensacola's fishing fleet rests at dockside. Today condominiums and the city's modern marina flank this area. Once 16 piers serviced ships docked alongside. Coal, phosphates, grain, cotton, fish, and lumber arrived by train and wagon to be loaded on to awaiting ships.

This image shows fishing boats docked at Pensacola. Red snapper fishing was an important industry along the Gulf coast and Pensacola had the largest fishing port. The over harvesting of

fish coupled with the severe hurricanes of 1906 and 1916 helped to bring about the demise of the red snapper boom by 1916.

Fish Industries, Pensacola, Fla.

The E.E. Saunders Fish Company owned a fleet of Pensacola fishing boats. The Saunders Company not only caught the fish, they also cleaned, dressed and packaged them for market in their factory. The Warren Fish Company had a rival fleet of fishing boats, but the two companies worked together to set fair prices for their catch.

Saunders Wharf, Pensacola, Fla.

Another postcard view of the E.E. Saunders Fish Company also depicts a fleet of Pensacola fishing craft. Pensacola is today a popular sport fishing destination. Today a number of small commercial fishing companies still operate at Pensacola. Among them is that run by the Patti family.

Felling a large pine tree near Pensacola, Fla.

This scene shows workers harvesting lumber. Several local lumber mills built their own railroads to take logs to the port, as this card shows. Though machines and animal power were used to transport and process the pine logs into dressed lumber, a great amount of human labor was still necessary to get the job done. The lumber industry attracted workers from all over Europe.

Some lumber barons built their mills near their harvesting sites, others nearer to the port. Probably the best known was the Arcadia Manufacturing Company owned by Forsyth, Hyer, and Simpson. Timothy Twitchell had a bucket making factory nearby. The largest lumber company was the Southern States Land and Timber Company that owned 340,000 acres, 4 sawmills, and their own railroad.

Mill owners without railroads floated their lumber downstream to the holding pens at the port. They marked each log with the mill's identity, so the owner could retrieve wayward logs. Logs were loaded through lumber ports cut into the ship's hull. As the water level rose, they lengthened the hole until the hold was full. The port was caulked to make a watertight seal.

1461 LOADING LUMBER FOR EXPORT, PENSACOLA HARBOR, FLA.

Between 1875 and 1895, Pensacola exported 4,168,319,000 feet of lumber, valued at $50 million. The railroads spent large sums to maintain and improve the port facilities. Over cutting timber and bank collapses brought the end of the lumber boom.

Loading Mahogany Logs from Water to Cars, Pensacola, Fla.

This view shows the Louisville and Nashville Railroad siding with the Marine Terminal in the background. As the pine forests diminished, importers began to bring in mahogany from South America. This trade continued until the 1940s. Timber was offloaded and floated to the dock where it was lifted onto rail cars. These took the lumber to nearby planing mills, or on to other factories inland.

Palafox Wharf and the port of Pensacola c. 1910s are shown in an aerial view. The building in the center of this view is the old L&N Railroad Marine Terminal Building. Hurricanes, fires, and the continued economic decline of the port of Pensacola frequently changed the size and

HARBOR VIEW, PENSACOLA, FLA.

shape of the port facilities. In the early 1970s the old Marine Terminal building, constructed in about 1900, was in danger of being demolished. To prevent the building's loss it was carefully lifted from its foundation and moved to its current site on Bayfront Parkway.

L & N RR Station

The L&N Railroad Station was constructed in 1912. The automobile hastened the closure of the station in the 1960s, and the building remained empty for 20 years. Slated for demolition the old terminal building was purchased in 1982 by the Hilton Hotels Corporation who re-designed it to serve as the main lobby, restaurant, and ballrooms for a 15-story tower addition that they completed in 1984.

The passenger and cargo steamship *Tarpon* started life in 1887 as the *Naugatuck*. In 1903 the ship was purchased by the Pensacola, St. Andrew & Gulf Steamship Company to operate a steamship service between Pensacola and Mobile, Alabama; St. Andrews Bay, Panama City; Apalachicola, and Carabelle. On August 31, 1937, she set sail on her 1,735th voyage only to sink off the coast of Panama City. Eighteen were drowned, including her master, Capt. Willis Greene Barrow.

Turpentine Industry in the South, Pensacola, Fla.

PHOTO BY U. S. FOREST SERVICE

This postcard shows part of Pensacola's pine barrens. The plentiful southern yellow pine trees brought great prosperity to the city. The trees were not only used for timber, but the sap was collected and distilled into other products. Metal or clay pots were attached to the trunk of the tree to collect the sap that bled from grooves cut into the bark.

Founded in 1902 the Consolidated Naval Stores Company produced tar, pitch, and turpentine from pine resin. Pitch, a concentrated form of tar, waterproofed and caulked ships; tar was used on the rigging; and turpentine was used as a solvent and thinner. Once the naval stores were manufactured, there was a need for barrels. The Pensacola Cooperage Company made wood barrels, and later the Florida Drum Company produced steel drums.

Newport Industries was one of the first chemical companies to open a plant in Pensacola. The plant opened in 1916 and made turpentine from decayed tree stumps. In 1928 they teamed with Armstrong Cork Company to make board from the plant's waste.

RICHARD GRIESSER & SON, BREWERY ARCHITECTS AND ENGINEERS

THE SPEARMAN BREWING CO., PENSACOLA, FLA.

On May 18, 1935, less than two years after Prohibition was repealed, Guy Spearman, owner of the Crystal Ice Company, opened the Spearman Brewery Company, 1600 South Barrancas Avenue. His interest in brewing beer began after a tour of a Mexican brewery. The building was state of the art for its time and later expanded as this postcard view shows here. The brewery slogan was "The Pure Water Does It." After restrictions on manufacturing "strong" beer ended (more than 4% alcohol content), Spearman's signature beer, "Spearman's Straight Eight" (8% alcohol content), debuted. The business closed in 1960, and the building was stripped of its equipment. Its rusted steel frame work was left in place until the early 1990s.

Five

THE MILITARY PRESENCE

The British Fort George was located on Gage Hill, Palafox Street. Fort George was one of several fortifications built during the British occupation of Pensacola (1763–1781). It was the last stronghold of the British during the siege against Spanish forces. This battle ended the British occupation of Pensacola. The Spanish would remain in control until 1821, when a treaty turned the Floridas over to the American Government.

The Americans built Fort Barrancas (shown at the top) on the site of Spanish Fort San Carlos, originally the site of the Royal Navy Redoubt built by the British in 1771. In 1781 the Spanish captured the area during the Siege of Pensacola. The Spanish added a water battery (cannons could "skim" cannon balls across the water), built between 1793 and 1797. The structure, named Bateria de San Antonio (shown below), survives to this day.

Fort Barrancas was built by the U. S. Army Corps of Engineers between 1839 and 1844. During the Civil War the Confederates held the fort until May 1862, when Federal forces took possession. Fort Barrancas and the Redoubt escaped serious damage during the Civil War. Fort Barrancas, the Redoubt, and the Water Battery are on Pensacola Naval Air Station and are run by the National Park Service.

Barracks and Parade Grounds, Fort Barrancas, Pensacola, Fla.

Above are the barracks and parade ground at Fort Barrancas. The enlisted men's barracks was built in 1850 and was home to 400 men. The U.S. Navy replaced the barracks in the 1930s. The building became the Naval School of Photography. Below, this card, dated 1917, shows soldiers drilling on the parade ground.

Target Practice Ft. Barrancas, Santa Rosa Island and Gulf of Mexico in the distance.

Target practice takes place at Fort Barrancas. Much of the fortification is under an earthen embankment. A tunnel runs from the fort to the water battery below. The terreplein that ran around the top of the fort had 32-pound gun emplacements. The fort ended its service in 1947. Today it is part of Gulf Islands National Seashore.

A sentry is seen on duty outside the courthouse during the trolley driver's strike in 1908. Horse-drawn street cars carried the public during the early 1880s. The city laid trolley lines and completed the electrification of the trolley by 1906. Between 1906 and 1932 the trolley was the only form of public transport available. Bus service began in 1931 using small metal and wood vehicles. In 1941 custom built mass transit buses were introduced.

The remains of Fort McRee lie on Fosters Bank. The Corps of Engineers built this fortification between 1834 and 1837 across the channel from Fort Pickens. Part of the brick fortifications built to defend the Navy Yard and Pensacola, the fort was damaged during the Civil War, and an early 20th-century hurricane destroyed the last arch (shown in the postcard). Today it is part of Gulf Islands National Seashore.

This image shows the disappearing rifle at Fort Pickens. Fort Pickens also housed Pensacola's first tourist attraction, Geronimo. In 1886 the renegade Apache and his band were sent to Fort Pickens. Every weekend people would come from Pensacola to watch the Apaches sing and dance. In 1888 the band was moved to Mount Vernon, Alabama, and finally to Fort Sill, Oklahoma, where Geronimo died in 1909.

These views show two of the guns at Fort Pickens. The top view is the 10-inch rapid fire disappearing rifle, built in 1895, and the lower view is of the 12-inch rifle, built in 1899. The U.S. Army Corps of Engineers built Fort Pickens between 1829 and 1834. During the Civil War Fort Pickens was the only Pensacola fortification not held by Confederate troops. After the Civil War, construction continued and modern gun batteries were added to the fortifications on Santa Rosa Island. The post of Fort Barrancas was used as a coastal artillery post and during the 1930s was the largest artillery training center in the South. Modern warfare rendered the forts obsolete and the U.S. Army closed Fort Pickens in 1947. In 1972 Fort Pickens became part of Gulf Islands National Seashore, and Fort Pickens, Fort Barrancas, and the Redoubt are open to the public.

Birds Eye view of U. S. Navy Yard, Pensacola, Fla.

In 1825 the Pensacola Navy Yard was designated, and construction began in 1826. The primary function of the yard was as a base for the Gulf Fleet, whose duty it was to stop pirates attacking shipping and to monitor the illegal slave trade. Named for the first two Navy Yard commandants, the newly created villages of Warrington and Woolsey were set aside for workers homes.

PENSACOLA, FLA. Navy Yard. Central Ave.

Pensacola Navy Yard was bordered by a high wall that separated Warrington to the west and Woolsey to the north from the yard. Personnel were evacuated during the yellow fever epidemics of 1863, 1882, and 1909, during which time maintenance of the yard was neglected. Further damage during the hurricane of 1906 sent the yard into a steady decline. The yard was officially closed in 1911.

Entrance to Reservation, U. S. Naval Air Station, Pensacola, Fla.

"OFFICIAL U. S. NAVY PHOTOGRAPH" 9A-H227

Above is the entrance to the Pensacola Naval Air Station; below are the Student Officer's Quarters. The Navy Yard reopened in 1914 as the Naval Air Station. Cmdr. H.C. Mustin was in command of the facility that included 10 tent hangars with wooden ramps leading down to the water and 15 pilots. Naval aviator #1 was Lt. T.G. Ellyson. By World War I, 38 pilots had received their wings, and Pensacola was still the only naval air station. By the end of the war 1,000 pilots had completed their training. In 1924 an unknown aviator named Charles Lindbergh stopped in Pensacola during a barnstorming tour. Returning to the air station after taking a passenger sightseeing, he crash landed short of the airfield, damaging his undercarriage.

Student Officers Quarters, U. S. Naval Air Station, Pensacola, Fla.

Above are the enlisted men's barracks. Below is the Chapel at Saufley Field, an auxiliary air base that opened in 1940. The airfield is named for Richard C. Saufley, Naval Aviator #14, killed in 1916 on Santa Rosa Island while trying to break his own endurance record. Naval aviators and flight surgeons trained there until the U.S. Navy decommissioned the facility in 1976. Saufley Field next housed the Naval Education Training Program Management Support Activity. The field finally closed during the base closings of the 1990s, and it is now the Saufley Field Federal Prison Camp.

The Chapel on the Naval Air Station was dedicated on Mother's Day, May 14, 1961. Services are held every Sunday in the Protestant and Catholic chapels. There is a shrine to Our Lady of Loreto, patroness of aviators. A statue of her, carved in Silva Val Gardena, Italy, shows her holding a U.S. Navy cutlass jet.

The entrance to the Naval Hospital is shown here. The third and fourth hospitals were built here, on the site of the first hospital compound. Built at a cost of $12,000 in 1835, the hospital was surrounded by a 12-foot brick wall. Urban legend claims they built the wall to keep out yellow fever carrying mosquitoes, which could not fly above eight feet. However, the mosquito-yellow fever connection was not known until after the wall was built.

An aerial view shows Naval Hospital number five, built in 1941. It is currently the headquarters of Naval Education and Training Command. The second hospital was in Building 16. The sixth and current hospital was built in 1976 and is on Highway 98.

In 1866 the Secretary of War designated this plot the National Naval and Military Cemetery. Barrancas National Cemetery now has 100 acres and more than 30,000 graves. In 1931 the navy moved graves from Old Warrington Cemetery into Barrancas. Dead from every war and conflict since the Second Seminole War in 1835 are buried here.

U. S. S. "MASSACHUSETTS."

The battleship USS Massachusetts was commissioned in 1896. Declared obsolete at the end of World War I, the ship came to Pensacola to be used for target practice by the guns at Forts Pickens. In 1921 the ship was deliberately holed below the waterline and sank just outside the entrance to Pensacola Bay. Now a protected underwater sanctuary, the old Massachusetts is a popular diving destination.

North Atlantic Squadron in Pensacola Bay, PENSACOLA, Fla.

The relationship between the U.S. Navy and Pensacola began in the 1820s when work began on the Navy Yard. This view, c. 1910s, shows a group of battleships from the North Atlantic Squadron anchored in Pensacola Bay. The squadron came to Pensacola regularly to rendezvous, before continuing on to conduct exercises in the Caribbean.

Naval vessels of all types came to Pensacola as evidenced by this group of four submarines docked at the Pensacola Naval Air Station in the 1920s. Pensacola was a frequent port of call for United States naval vessels that held operations in the Gulf of Mexico. Palafox Street had dozens of bars where sailors could let off steam.

A group of pre–World War I torpedo boats and the former Spanish-owned dry dock are shown docked at the Pensacola Navy Yard. The dry dock was later used by the Bruce Dry Dock Company at downtown Pensacola to perform repairs to civilian merchant ships.

U. S. S. PENSACOLA VISITS THE CITY WHICH IT WAS NAMED AFTER

The heavy cruiser USS *Pensacola* CA-24 visits her namesake city. The giant ship, the third to bear the name Pensacola, was launched on April 25, 1929, and christened by Mrs. Josephine Knowles Seligman, a native Pensacolian. The powerful ship was involved in nearly every major sea battle of the Pacific theater in World War II and won 13 Battle Stars for her service. Decommissioned after the war, the USS *Pensacola* was used as a test ship at the Bikini Atoll atomic bomb tests in 1946. Though badly damaged, the old cruiser refused to sink and was later sunk with torpedoes and gunfire in 1948.

U. S. S. Battleship Pensacola, in moonlight on Pensacola Bay, Florida

A Few of the School Seaplanes and Hangars at U. S. Naval Air Station, Pensacola, Fla.

This early view of the Naval Air Station shows some of the seaplanes and the wooden ramps where the aircraft entered the water. The first naval aviation flight was completed on February 2, 1914, by Lt. John Towers (aviator #3) and Ensign Godfrey Chevalier (aviator #7) in a wooden Curtiss F-boat. The flight lasted 20 minutes, and the seaplane reached a height of 1,000 feet.

This view shows a Burgess-Dunne seaplane with U.S. Cruiser *Columbia* in the background. The Burgess Company built a seaplane version, and the U.S. Navy received its first machine in 1916. In 1919 the navy converted the collier USS *Jupiter* to become the first American aircraft carrier USS *Langley*. In 1922 Lt Cdr. Godfrey Chevalier (aviator #7) trained the navy's first carrier pilots at Naval Air Station in Norfolk, Virginia.

This view is of a navy observation kite balloon. The military had been using observation balloons since the Civil War. The first balloon arrived in Pensacola in 1916, and a few days later a balloon broke its moorings. Eighty-four miles away it hit a pine tree where it remained stuck. The navy created a balloon field on the recently demolished town of Woolsey.

This postcard shows the B-class airship that arrived in Pensacola in 1917. The U.S. Navy used them during World War I for training and coastal patrols. Above the B-class dirigible is the E-1 airship that spent its entire career in Pensacola. The navy built dirigible hangars on the Woolsey balloon field. All lighter-than-air training ended at Pensacola in 1921.

A United States Naval cadet returns from a solo flight in an N-9 training machine. The N-9 was used between 1916 and 1926. The navy replaced the tent hangars with three steel framed hangars in 1916 and also replaced the wooden sea ramps with concrete ramps that are still there. As the air station grew, the village of Warrington was moved across Bayou Grande to make way for more buildings.

As with all new forms of transportation, accidents often happened. Lt. James Murray became the first fatality when he drowned after crashing into Pensacola Bay two weeks after the air station opened. Between 1914 and 1918, 25 aviators were killed during training at Pensacola.

This seaplane was the single-engine Curtiss HS-2L, driven by the efficient Liberty motor. The Wright and Curtiss Companies both competed to provide machines for the military. Their airplanes had very different controls, and pilots were certified only in one type. After several fatal accidents in Wright machines, the navy began to phase out Wright-built seaplanes.

Above, a Curtiss N9 seaplane prepares for take off, c. 1916. Below, a Curtiss Flying Boat is launched by catapult from a battleship, 1919. As early as 1911, the navy had been experimenting with how to launch a plane at sea. They conducted the first sea trials using catapults in Pensacola. In 1916 an AB-2 flying boat flown by Lt. Pat Bellinger (aviator #8) was launched by catapult from a coal barge in Pensacola Bay. Lt. Cmdr. Henry C. Mustin made the first ship launch from the USS *North Carolina* in the bay later that year.

Above, aircraft fly over the Naval Air Station. Early aviators had a support system that included a 240-foot high observation tower whose spotters could alert emergency crews; boats and launches used to rescue pilots from the bay; and "solo coffin," or sea sled, which followed first-time solo fliers around the bay in case of mishaps. Below is the *Mary Ann*, a self-propelled marine derrick that lifted crashed aircraft from the water onto her deck.

This is the "yellow peril," or an NS-1 trainer. This was a single-engine PT-13D "Kaydet" biplane manufactured by Stearman Aircraft (which became Boeing in 1938). Training aircraft were typically painted bright yellow during World War II. The U.S. Navy ordered the first aircraft in 1934. Some former students have gone on to great careers, including William F. "Bull" Halsey, who was commanding officer of the Air Station in 1938.

Before Pearl Harbor, Pensacola's Naval Air Training Center trained 800 pilots a month. This was raised to 2,500 once the United States entered World War II. By 1943, 20,000 students had received their wings. During World War II, U.S. Navy and Marine aircraft had destroyed 15,000 enemy aircraft, 161 Japanese warships, 447 Japanese merchant ships, and 63 German submarines.

"Wings over Pensacola" — U.S. Navy Scout Bombers on Patrol

"Annapolis of the Air," Pensacola, Fla.

These U.S. Navy Scout Bombers were the eyes of the fleet. Usually based aboard carriers and cruisers, their long-range, high-speed capabilities made them the perfect collectors of information. Deployed from their ships, they would search for enemy shipping and relay this advance information back to their commander-in-chief.

Chevalier Field, Naval Air Station, Pensacola, Fla.

OFFICIAL U. S. NAVY PHOTOGRAPH FROM A DRAWING BY VERNON HOWE BAILEY

In 1922 the Woolsey Balloon Field became Station Field, a landing field for aircraft. In 1936 the U.S. Navy renamed the field "Chevalier Field" in honor of Lt. Cdr. Godfrey de Courcelles Chevalier (aviator #7), who died in an air crash in 1922. It was the primary navy airfield until the arrival of jets. The runways were too short to accommodate them, and the airfield closed in 1965.

Pilots Manning Planes, NAAS, Ellyson Field, Pensacola, Fla.

OFFICIAL U. S. NAVY PHOTOGRAPH

The navy opened Ellyson Field near Davis Highway in 1941 as its third auxiliary airfield. It was named for Lt. Theodore G. Ellyson (aviator #1), who was killed during a night flight in 1928. Ellyson received his wings in 1911 and flew the U.S. Navy's first aircraft, the "Triad" the same year. The airfield officially closed in July 1979, and Ellyson Field Industrial Park is now on the site.